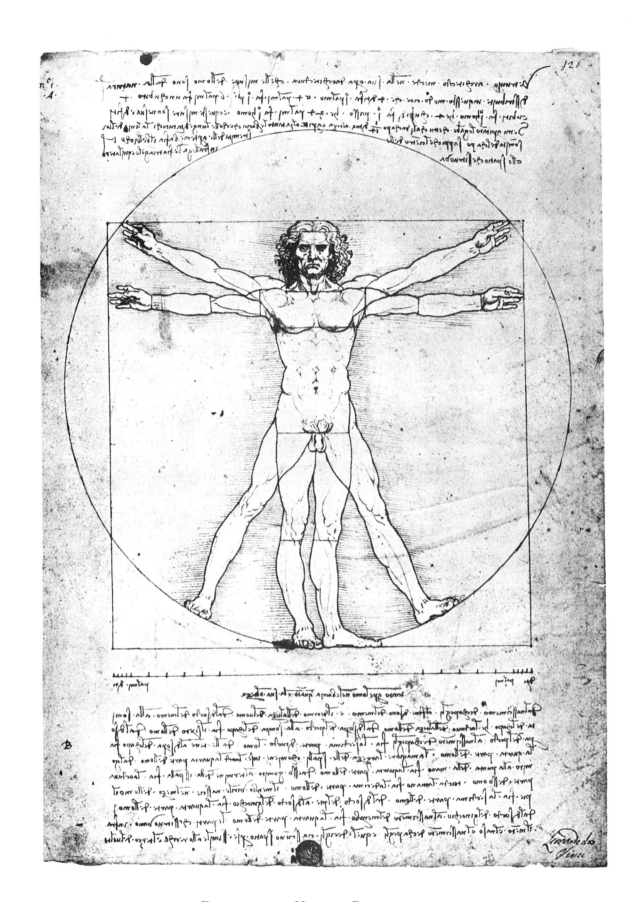

Diagram of Human Proportions

Leonardo's
ANATOMICAL DRAWINGS

Leonardo da Vinci

DOVER PUBLICATIONS, INC.
Mineola, New York

Bibliographical Note

Leonardo's Anatomical Drawings is a new work, first published by Dover Publications, Inc., in 2004.

Library of Congress Cataloging-in-Publication Data

Leonardo, da Vinci, 1452–1519.
 Leonardo's anatomical drawings / Leonardo da Vinci.
 p. cm. — (Dover art library)
 ISBN-13: 978-0-486-43862-7 (pbk.)
 ISBN-10: 0-486-43862-7 (pbk.)
 1. Leonardo, da Vinci, 1452–1519. 2. Anatomy, Artistic. I. Title: Anatomical drawings. II. Title. III. Series.
NC257.L4A35 2005
 2004056716

Manufactured in the United States by Courier Corporation
43862704
www.doverpublications.com

Note

THE EPITOME OF THE RENAISSANCE MAN, LEONARDO DA VINCI (1452–1519) was equally accomplished in the fields of anatomy, engineering, science, and the arts. He was born in Vinci, a village near Florence, the illegitimate son of a notary and a peasant woman. Raised mostly by his paternal grandfather, the young Leonardo displayed great natural talent that would later be recognized as sheer genius. His artistic and intellectual accomplishments were many, and he excelled as a painter, sculptor, architect, and engineer. In 1467 Leonardo entered the studio of sculptor Andrea del Verrocchio as an apprentice, acquiring a wide variety of skills in the arts before working as an artist and technical advisor on architecture and engineering in Milan.

Over the course of the next several years, Leonardo traveled between Florence and central Italy, working as a map maker and civil engineer. Around 1503 he settled back in Florence, where he completed some of his most famous paintings, the *Mona Lisa* foremost among them. He also continued his studies of anatomy and biology, for which he dissected human cadavers to further study and sketch the human form and comprehend its functions. In 1516 Leonardo left Italy to become architectural advisor to King Francis I of France.

In his later years, Leonardo concentrated his efforts on his notebooks, which he wrote in "mirror script" from right to left in order to keep prying eyes from reading his writing. Within these books, he kept copious notes on a host of different disciplines, including botany, geology, hydraulics, astronomy, and flight science. Sketchbooks containing his own experimental ideas for future inventions—one of which was a precursor to the modern helicopter—showcase his incredible abilities as an artist.

Leonardo's anatomical drawings were the most significant achievements of Renaissance science. Fascinated by the structure of the human body, Leonardo originally pursued the study of anatomy for his training as an artist. Before long, his interest in the human form flourished into an independent area of research. Although his early studies dealt with the skeleton and muscle structure, Leonardo managed to combine both anatomical and physiological functions in his research. His studies soon delved into the functions of the internal organs, especially the brain, heart, and lungs. In Milan and Florence, he received instruction from doctors and anatomists, thereby gaining invaluable practical knowledge of internal organs. It was during this time that he performed some dissections of corpses on his own. Taking into account all of Leonardo's immeasurable contributions to society, it is his anatomical drawings, which represent the culmination of his artistic and scientific aims, that truly laid the groundwork for modern scientific investigation and teaching.

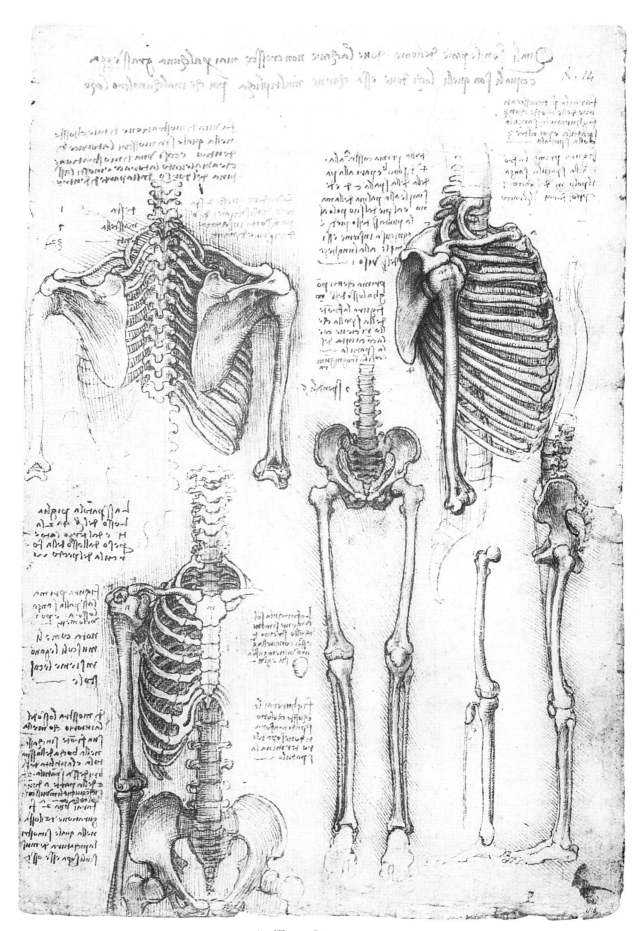

1. THE SKELETON

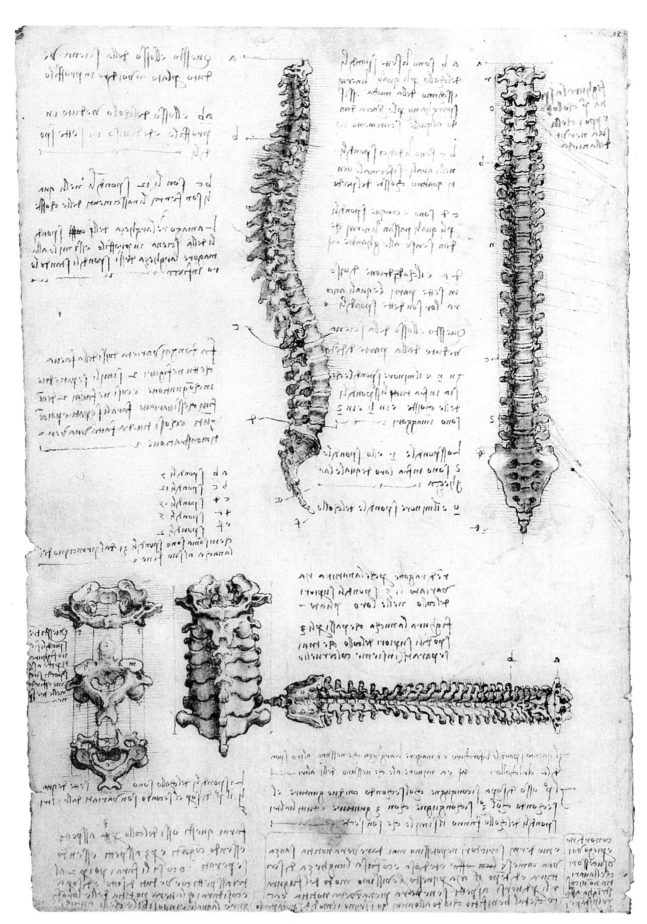

2. THE VERTEBRAL COLUMN

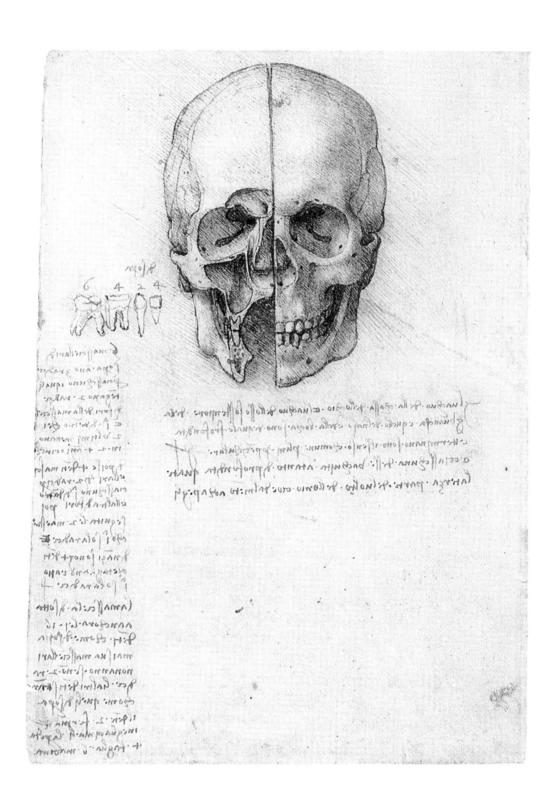

3. The Skull: Anterior View

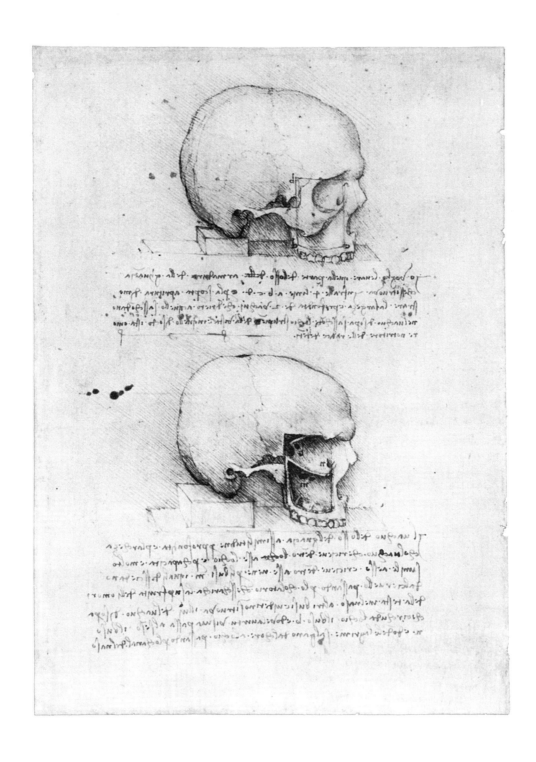

4. The Skull: Lateral View

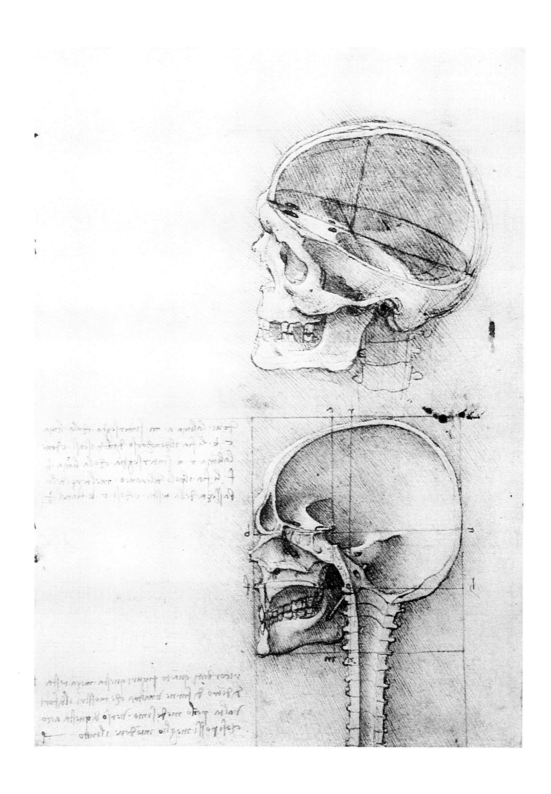

5. THE SKULL: INTERIOR VIEW AND SAGITTAL SUTURE

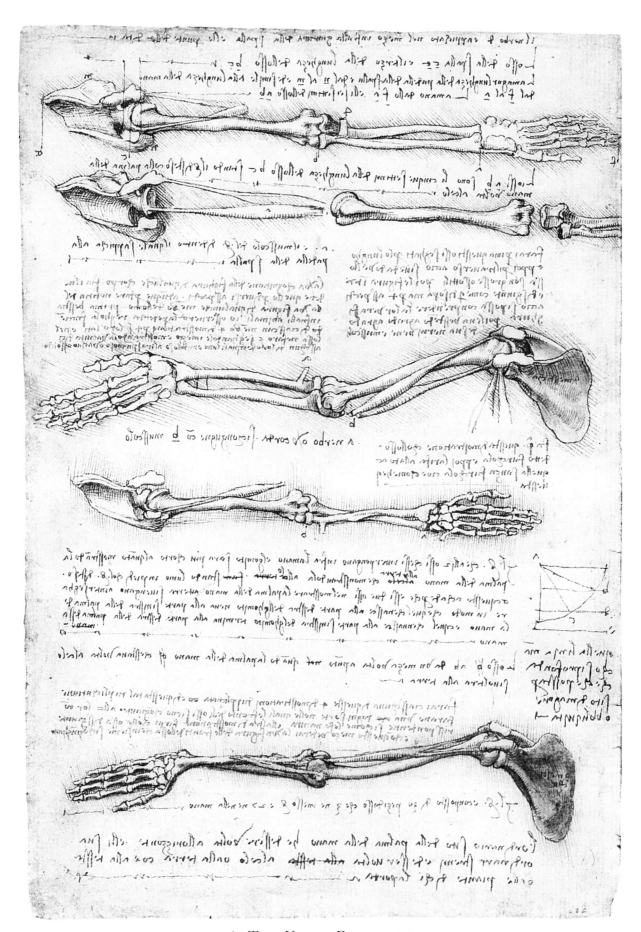

6. The Upper Extremity

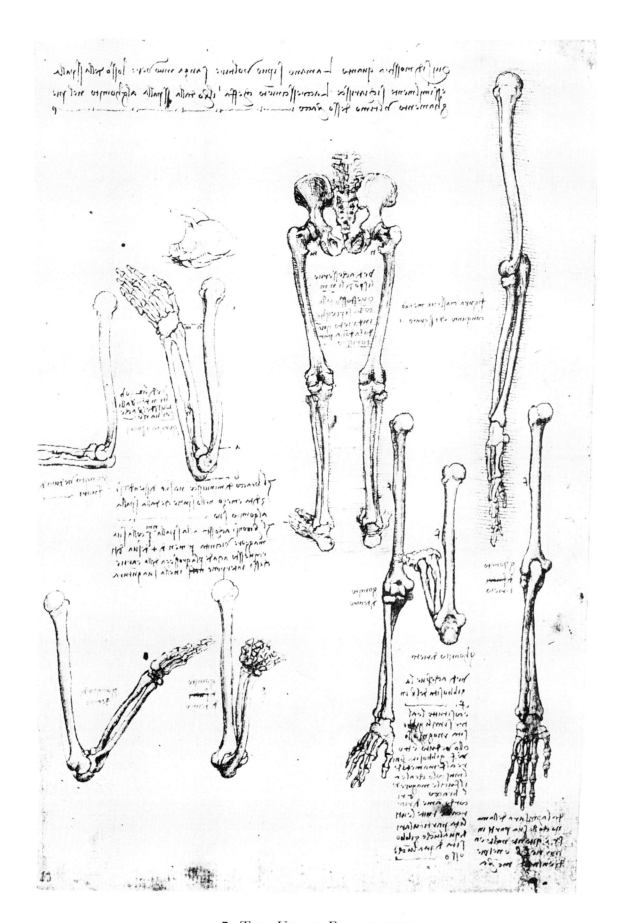

7. THE UPPER EXTREMITY

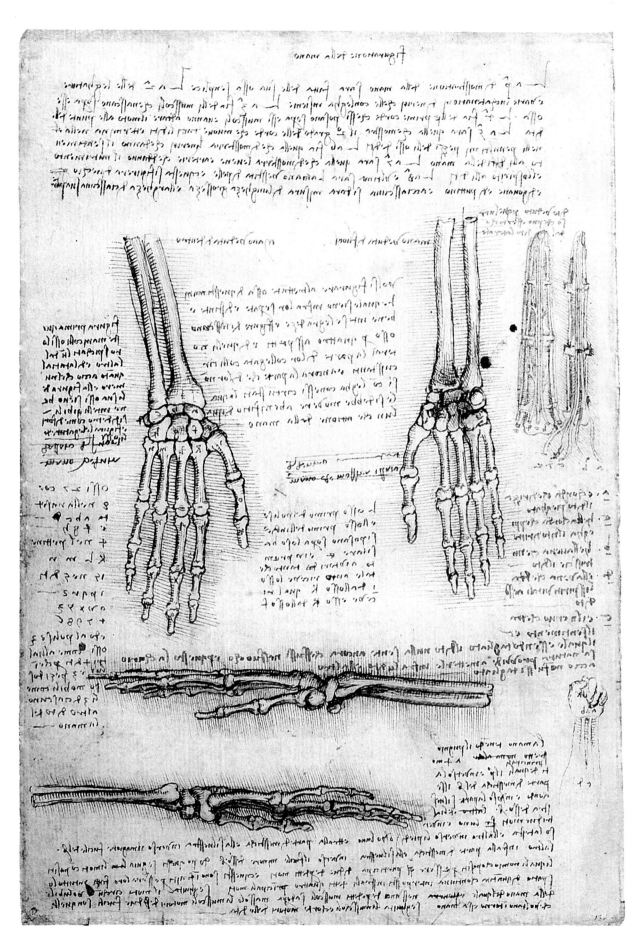

8. REPRESENTATION OF THE HAND

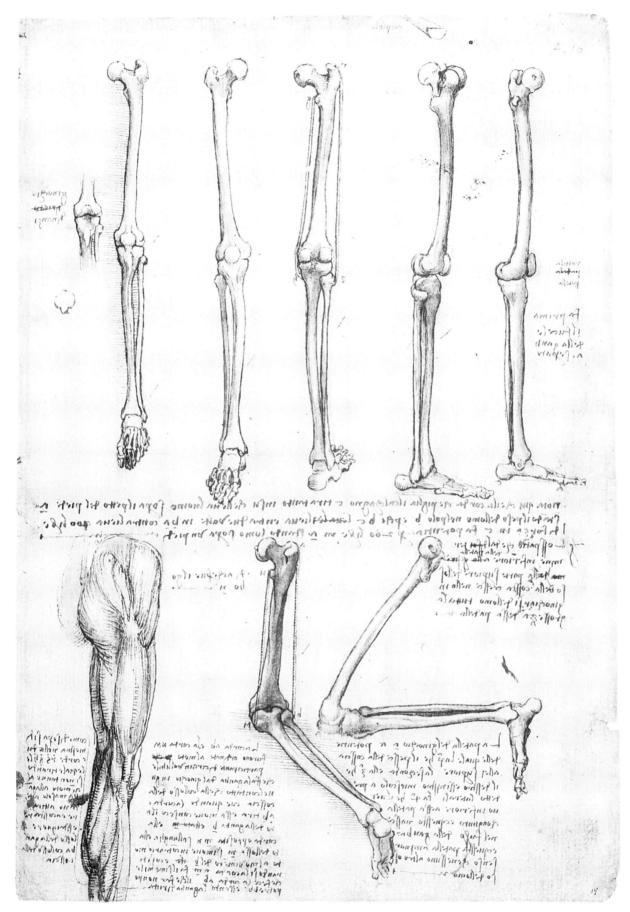

9. THE LOWER EXTREMITY

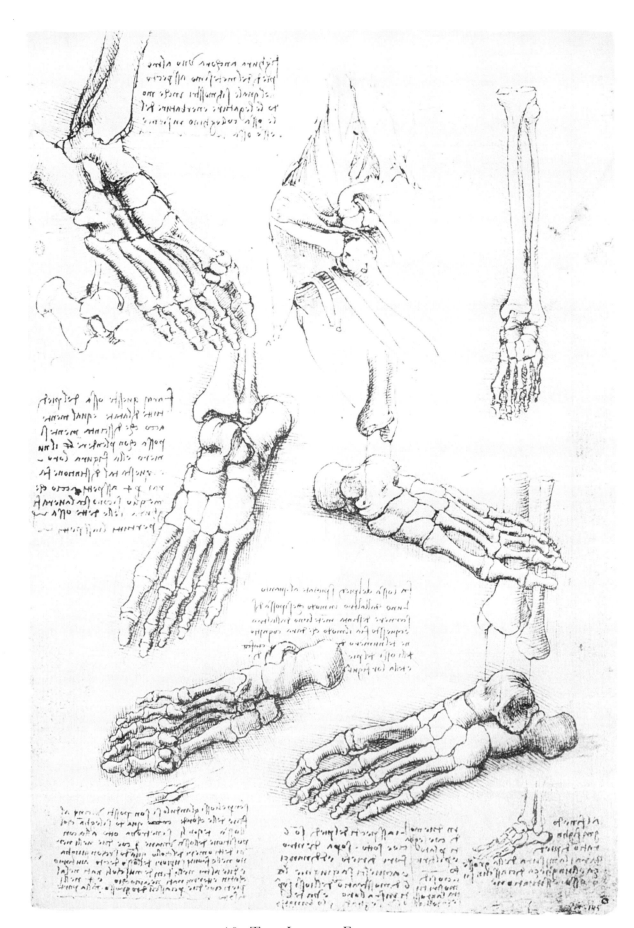

10. The Lower Extremity

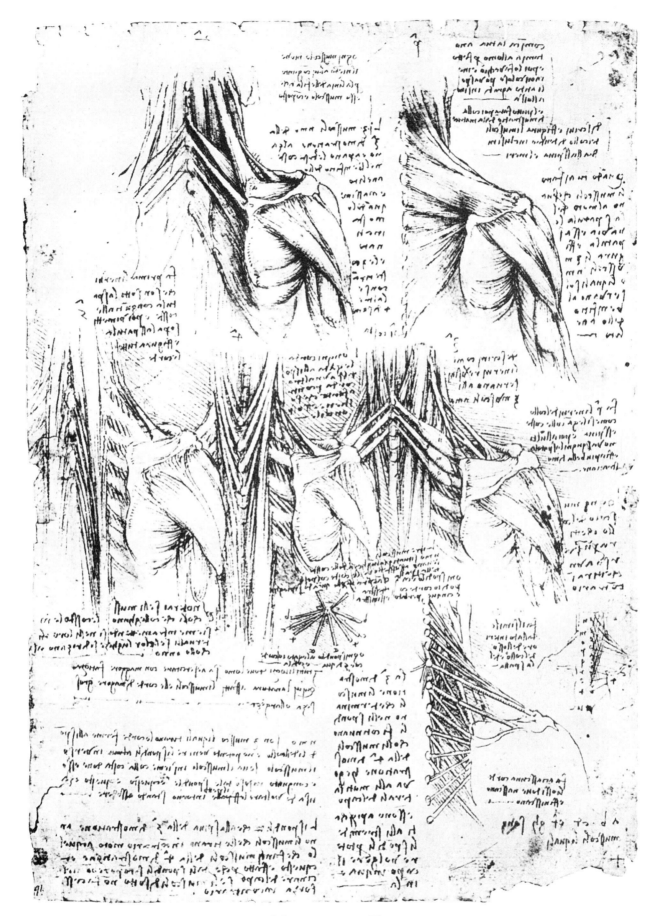

11. MYOLOGY OF TRUNK

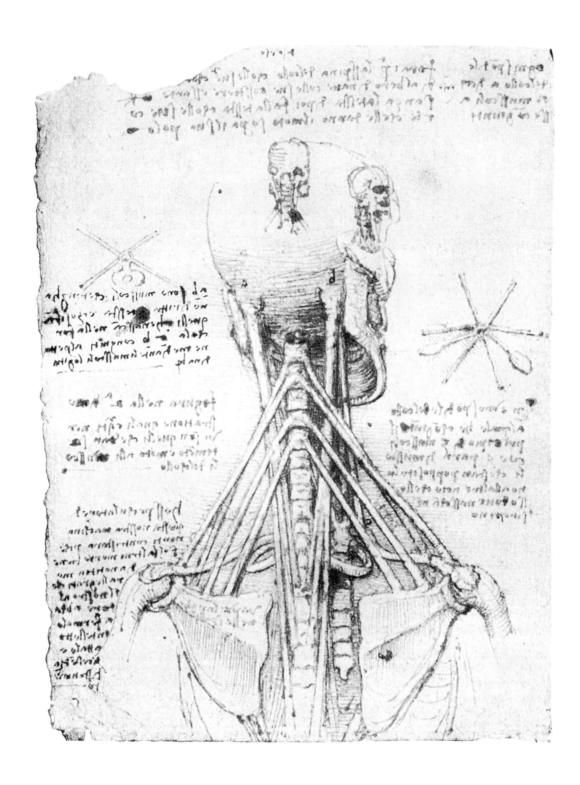

12. Myology of Trunk

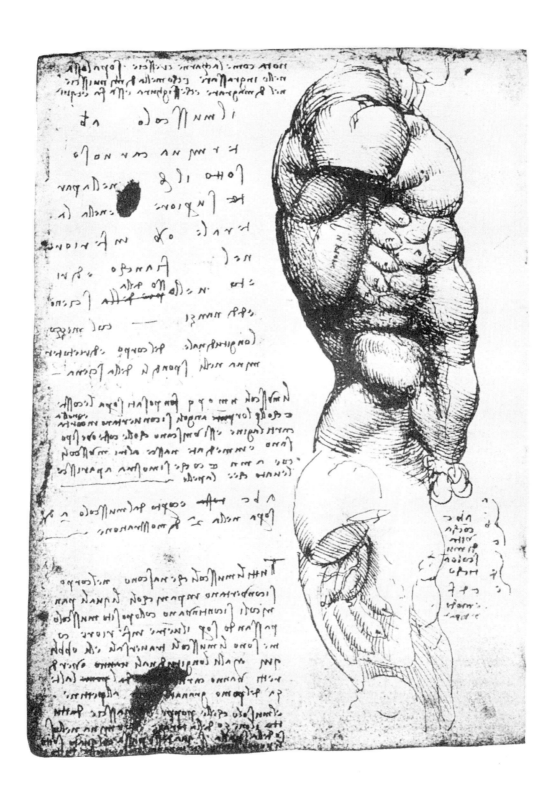

13. Myology of Trunk

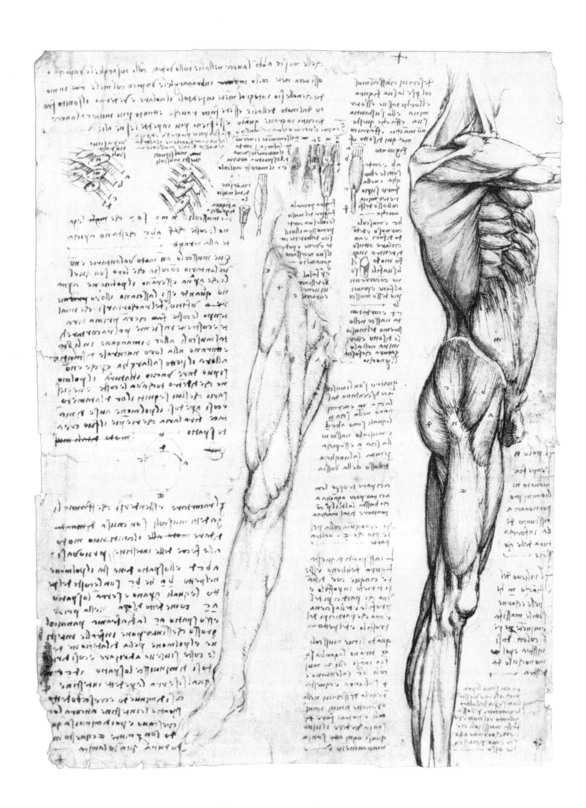

14. MYOLOGY OF TRUNK

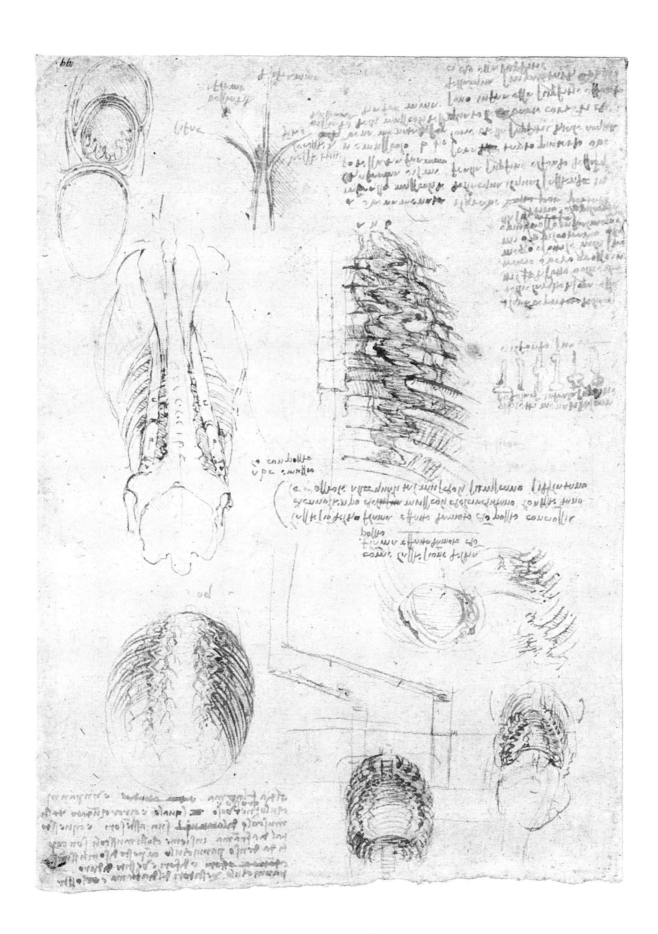

15. Myology of Trunk

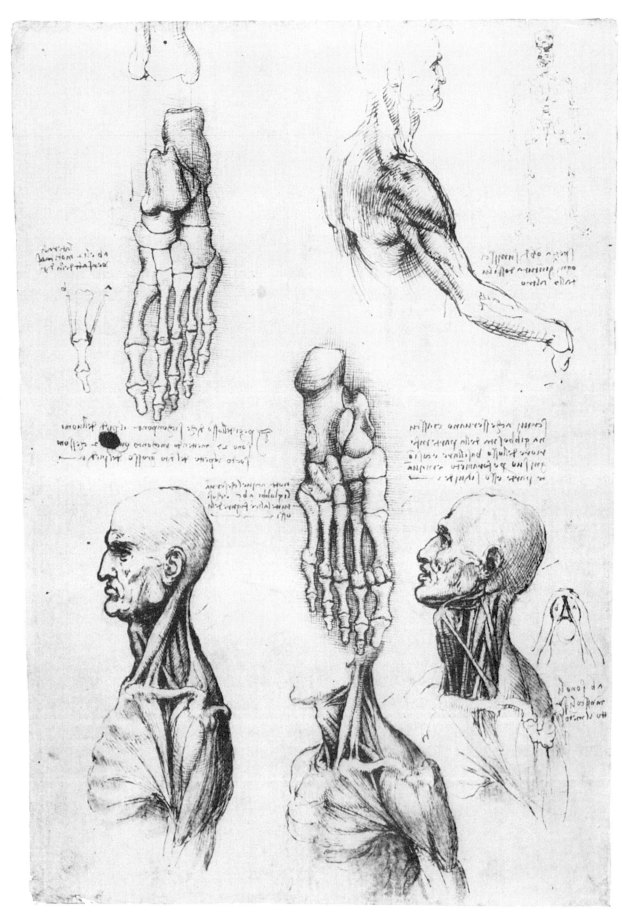

16. MYOLOGY OF HEAD AND NECK

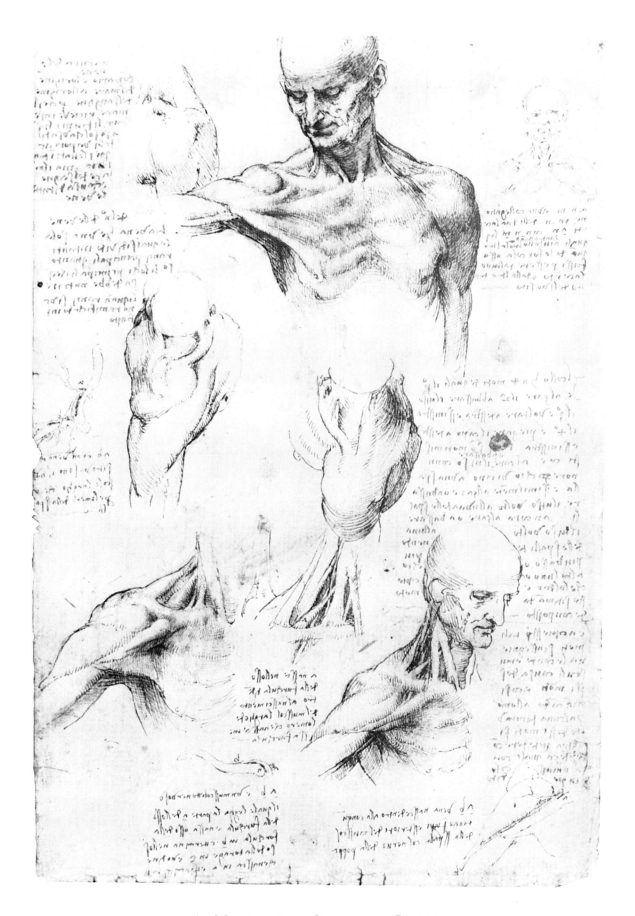

17. MYOLOGY OF SHOULDER REGION

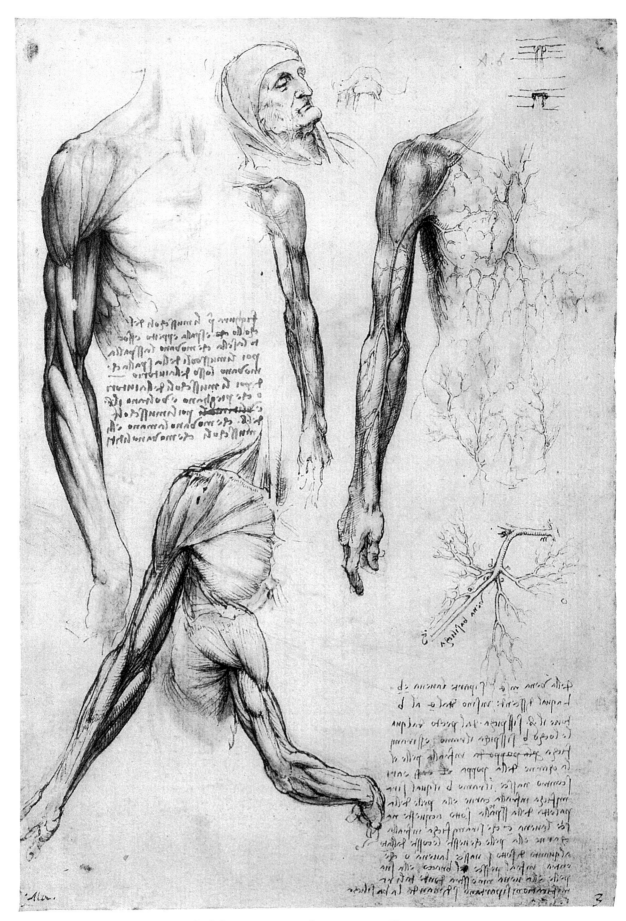

18. Myology of Shoulder Region

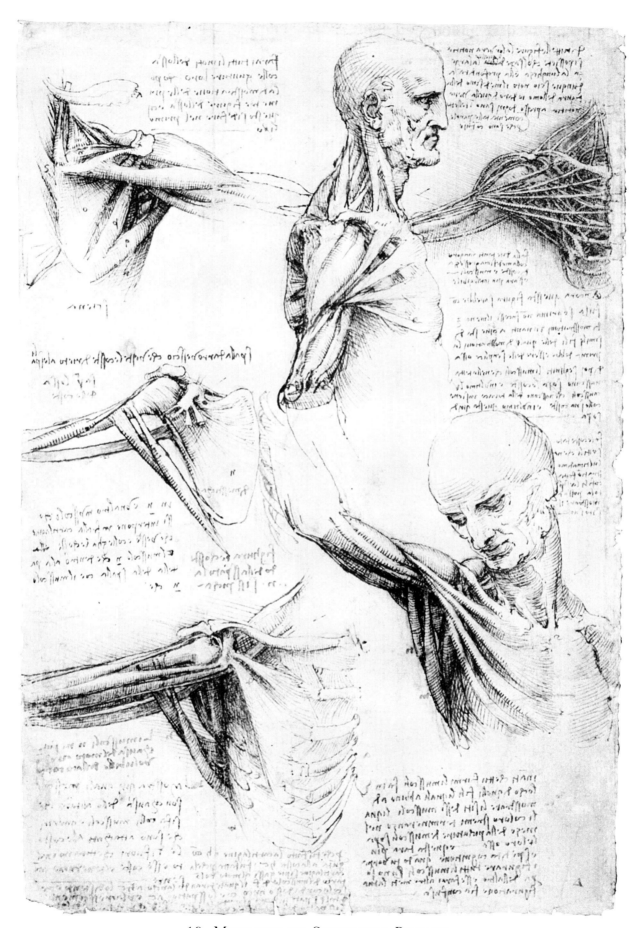

19. MYOLOGY OF SHOULDER REGION

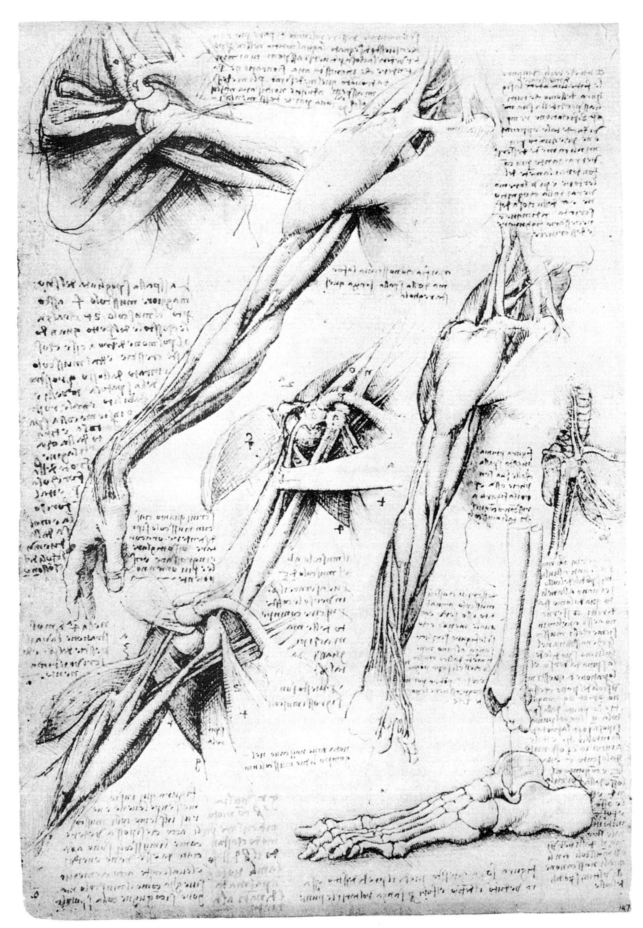

20. Myology of Shoulder Region

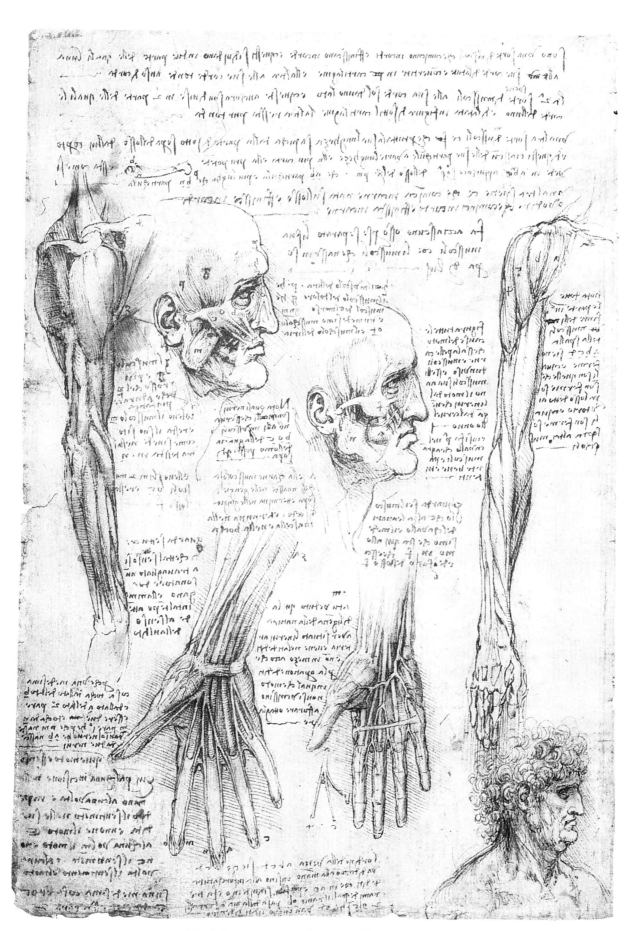

21. Myology of Upper Extremity

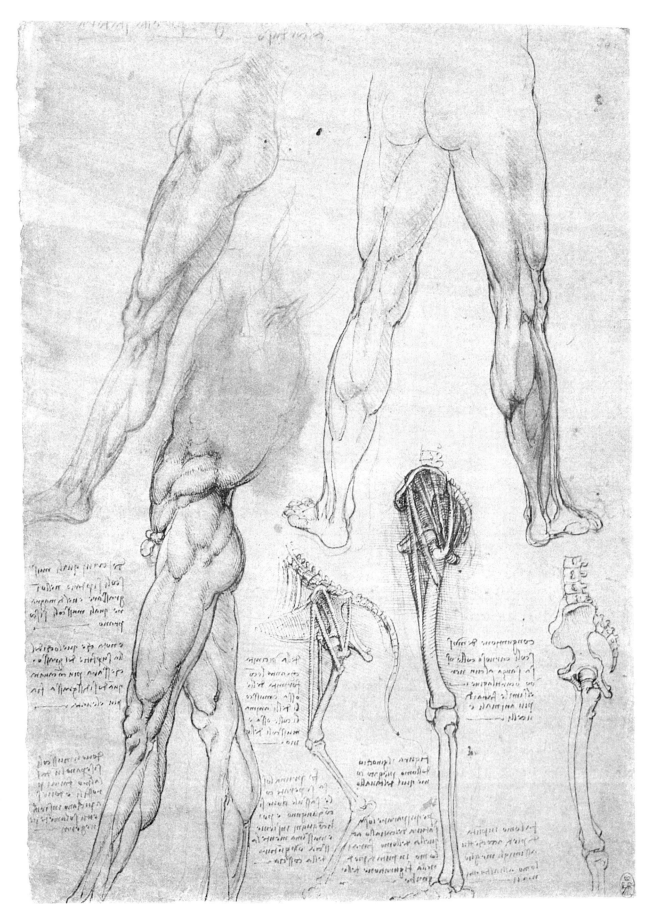

22. MYOLOGY OF LOWER EXTREMITY

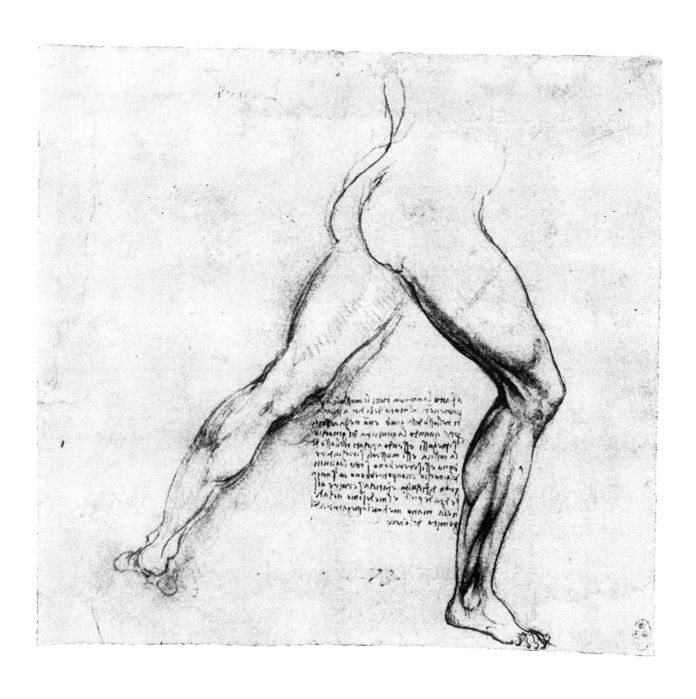

23. Myology of Lower Extremity

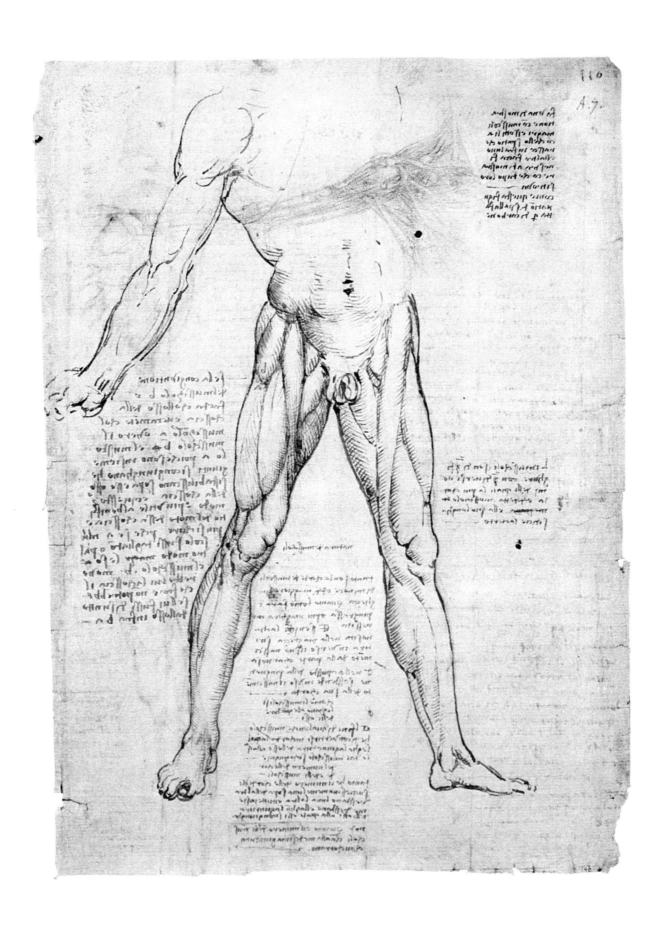

24. MYOLOGY OF LOWER EXTREMITY

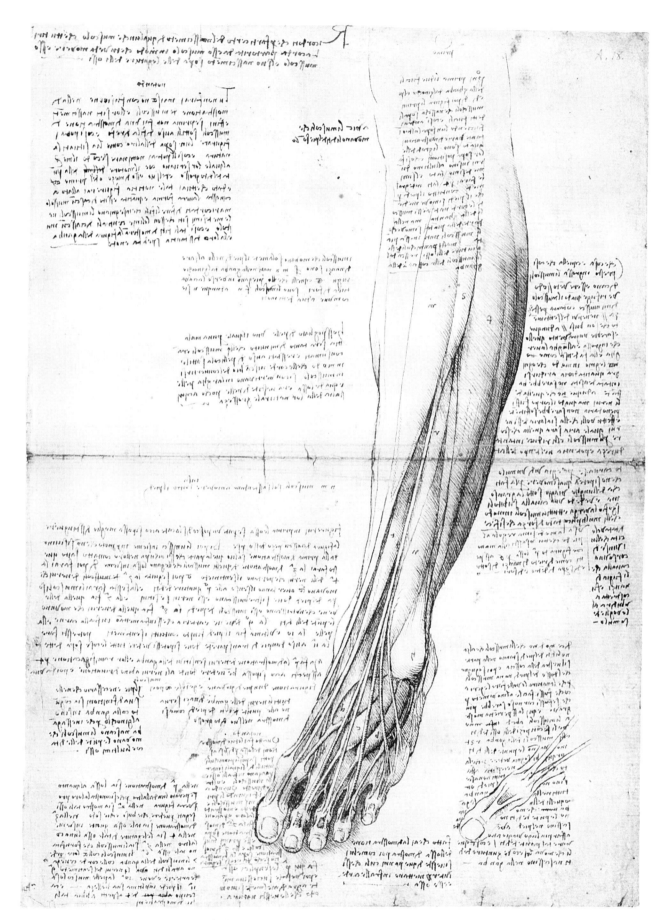

25. MYOLOGY OF LOWER EXTREMITY

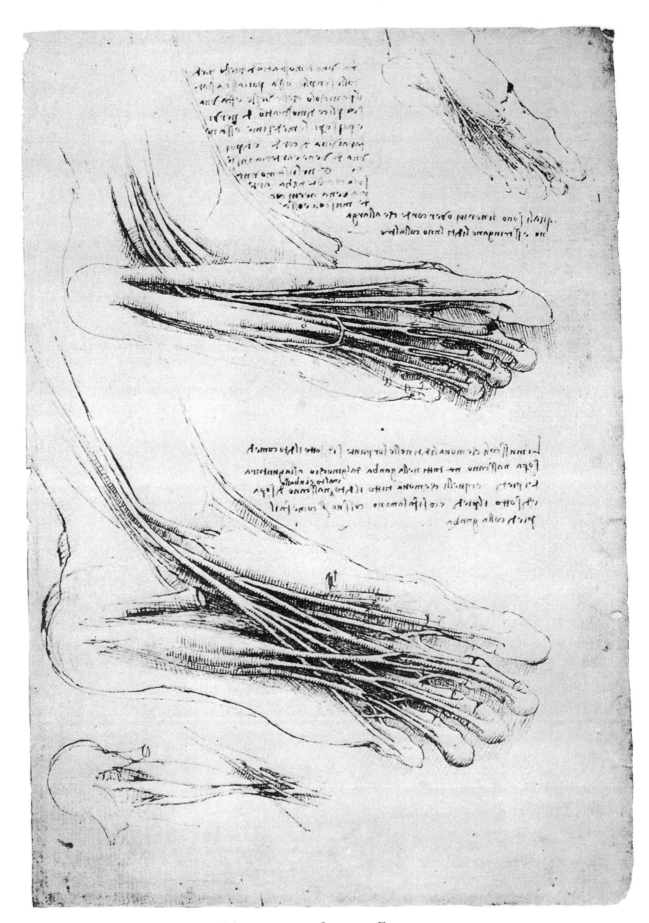

26. Myology of Lower Extremity

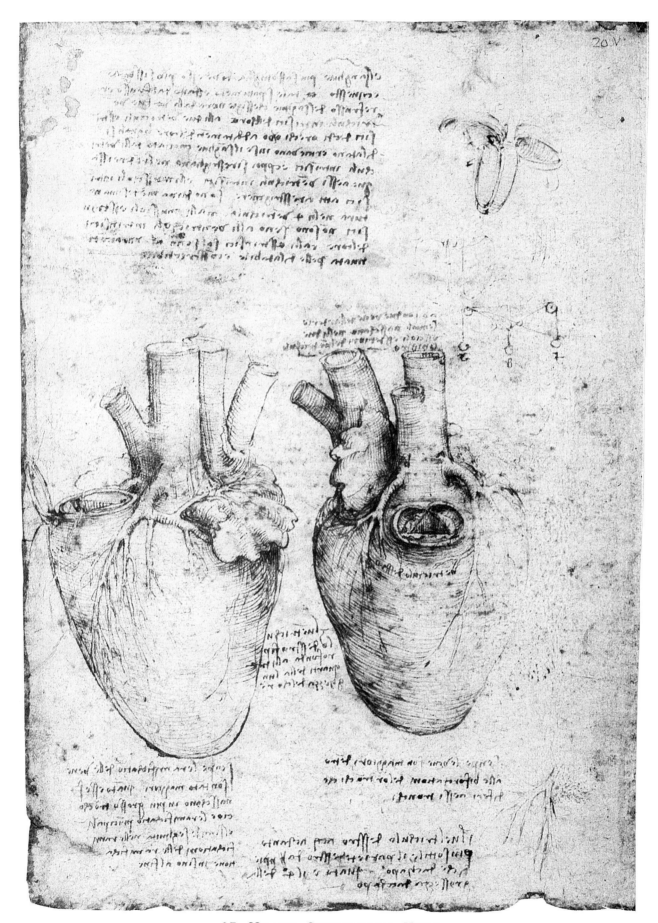

27. Heart: Superficial View

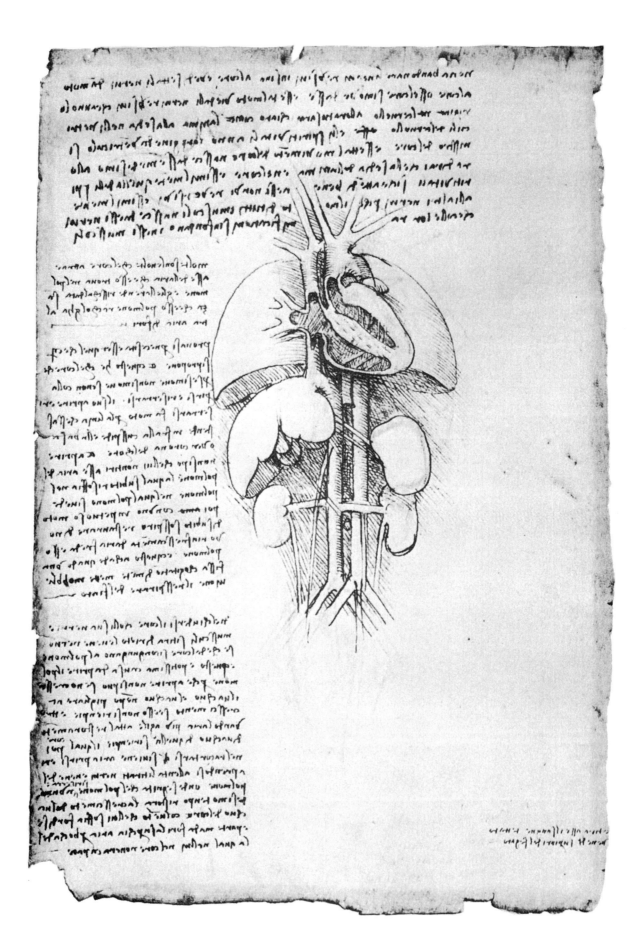

28. Ventricles of the Heart

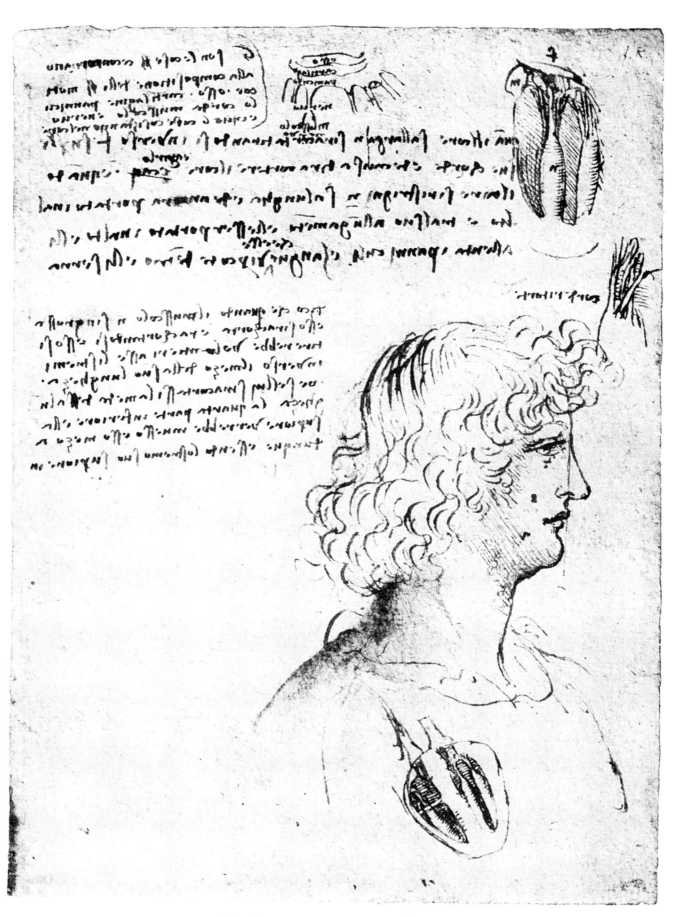

29. VENTRICLES OF THE HEART

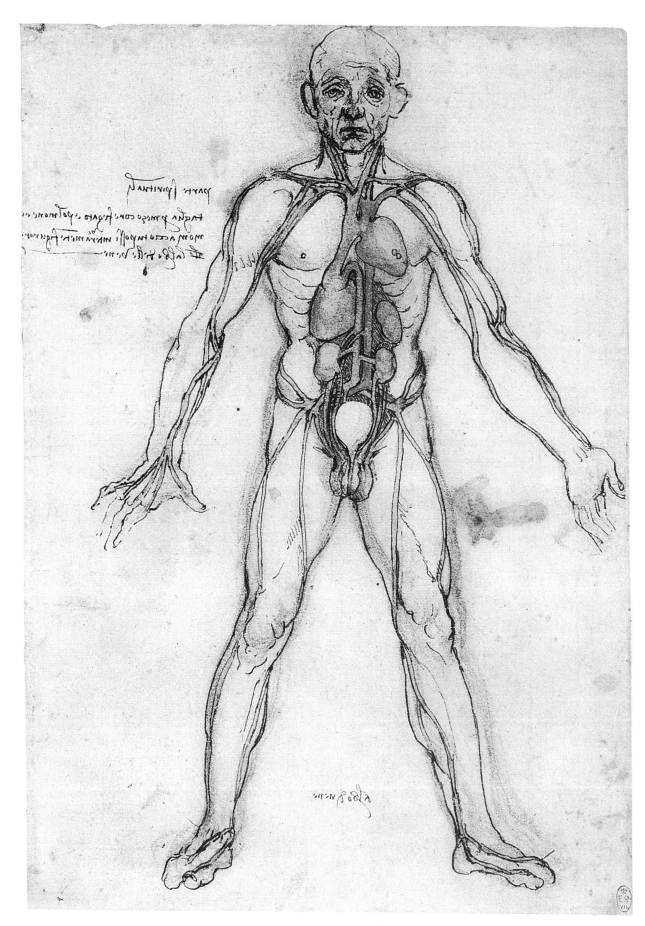

30. CARDIOVASCULAR SYSTEM

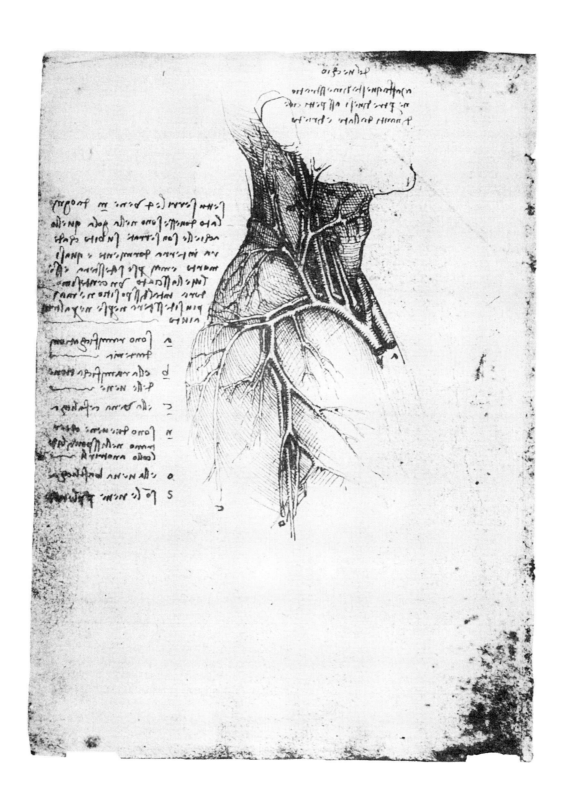

31. Cardiovascular System

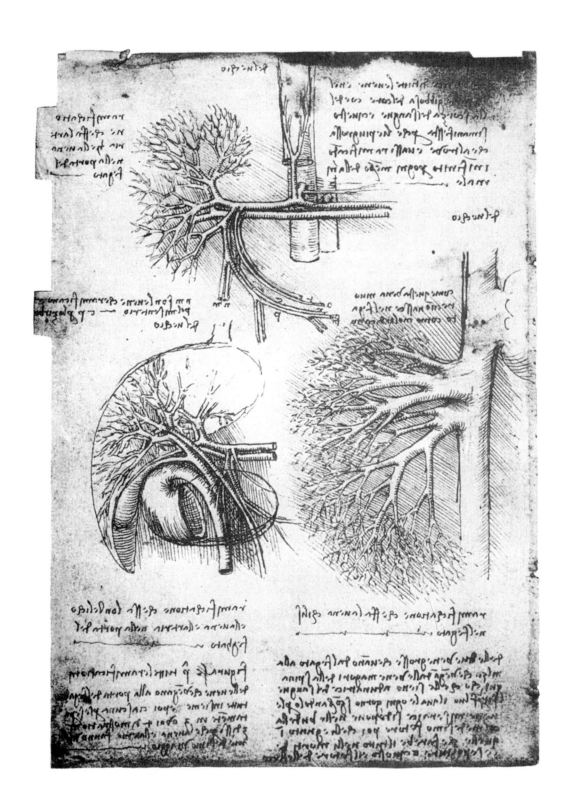

32. Cardiovascular System

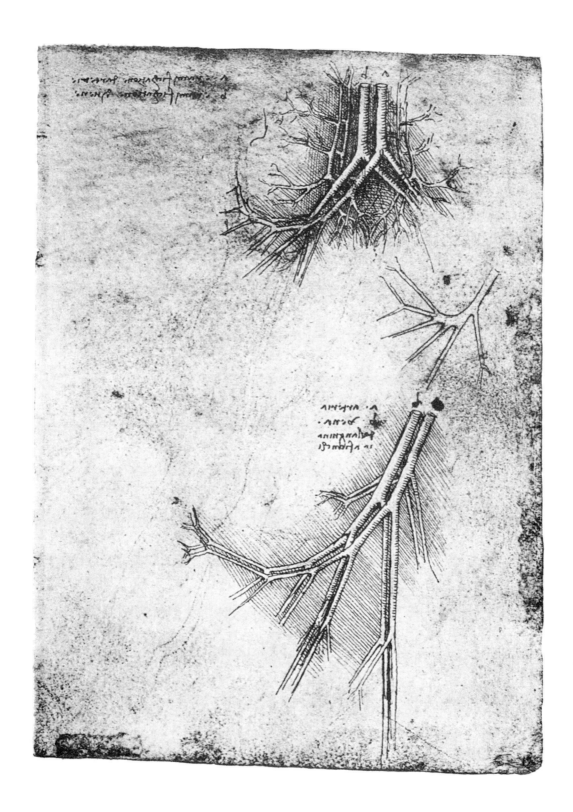

33. CARDIOVASCULAR SYSTEM

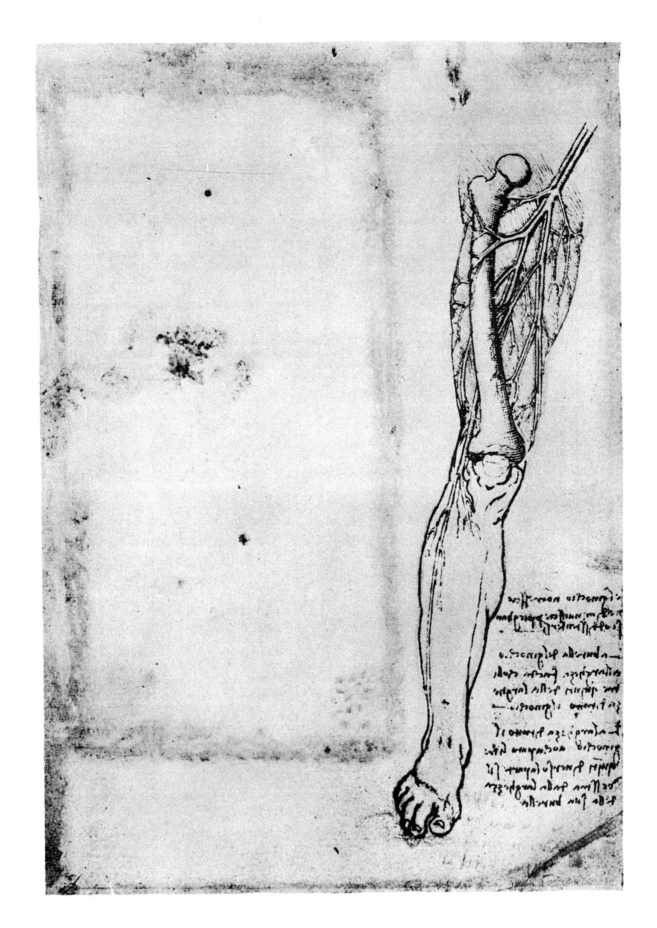

34. CARDIOVASCULAR SYSTEM

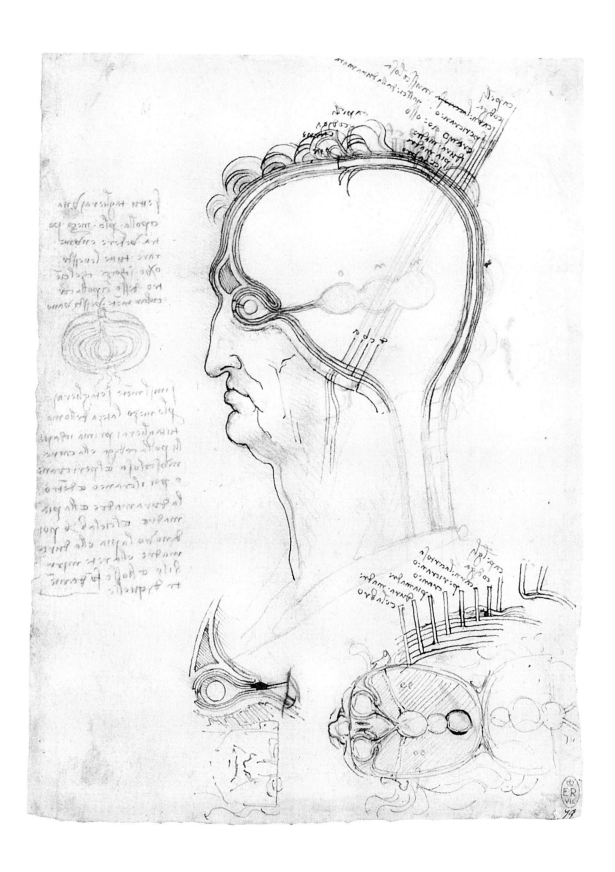

35. CENTRAL NERVOUS SYSTEM AND CRANIAL NERVES

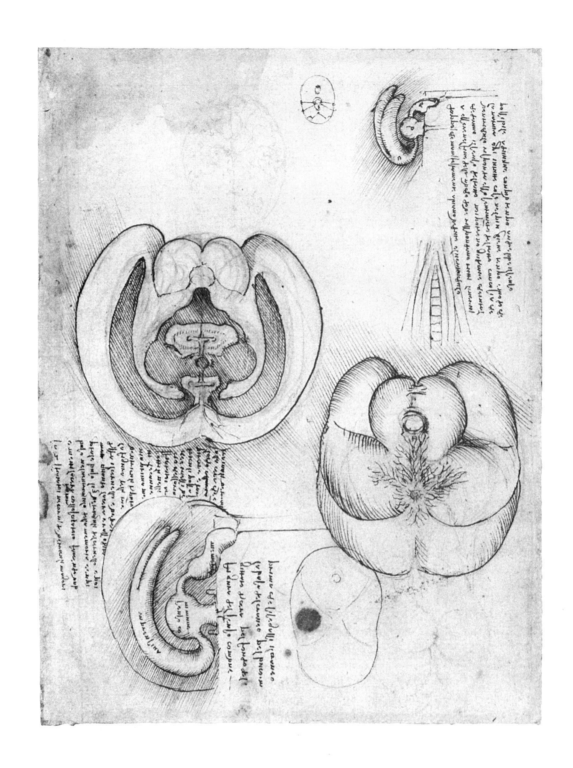

36. Central Nervous System and Cranial Nerves

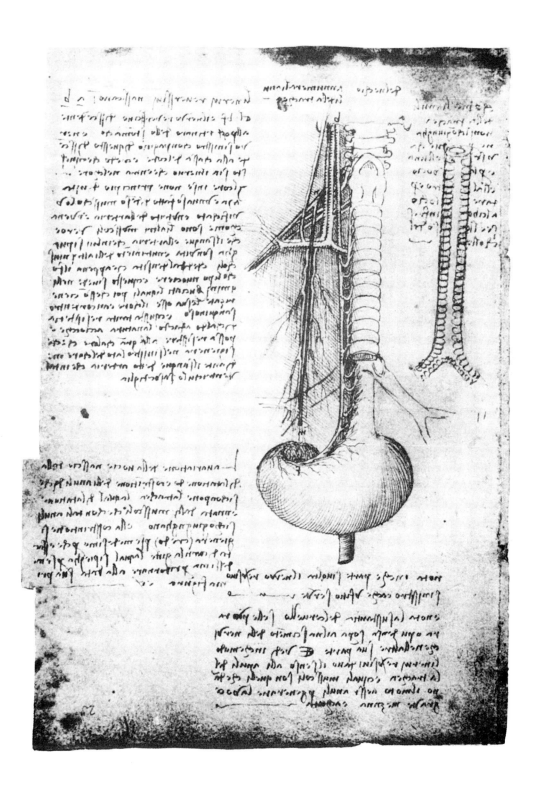

37. CENTRAL NERVOUS SYSTEM AND CRANIAL NERVES

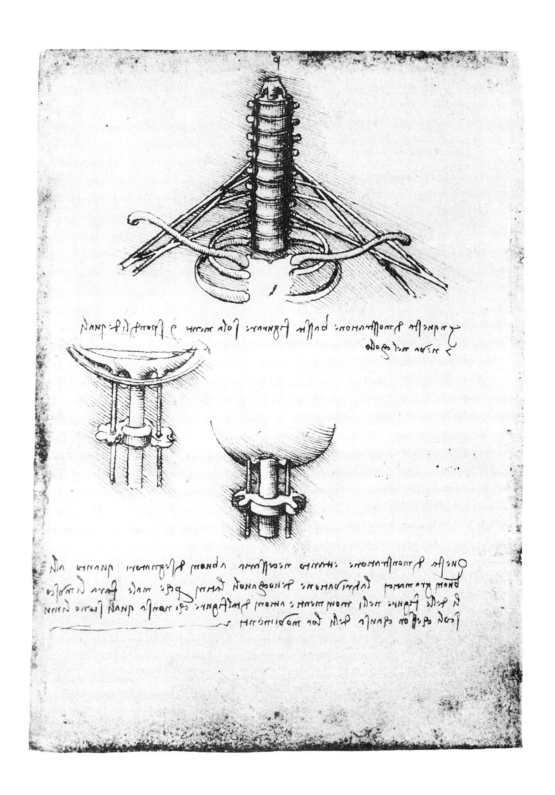

38. PERIPHERAL NERVES: UPPER EXTREMITY

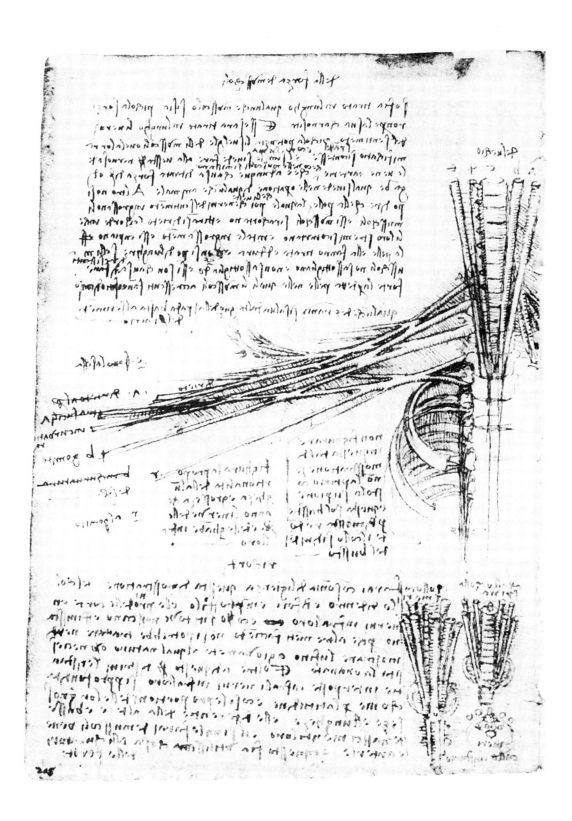

39. Peripheral Nerves: Upper Extremity

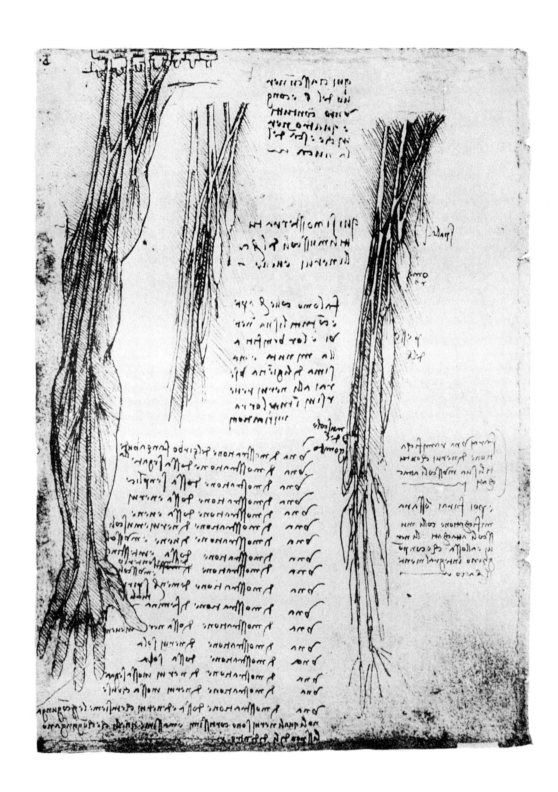

40. Peripheral Nerves: Upper Extremity

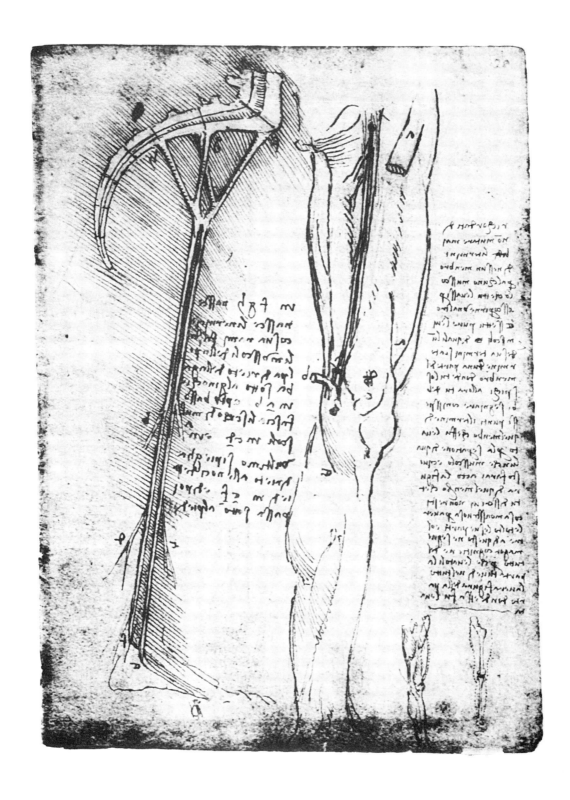

41. PERIPHERAL NERVES: LOWER EXTREMITY

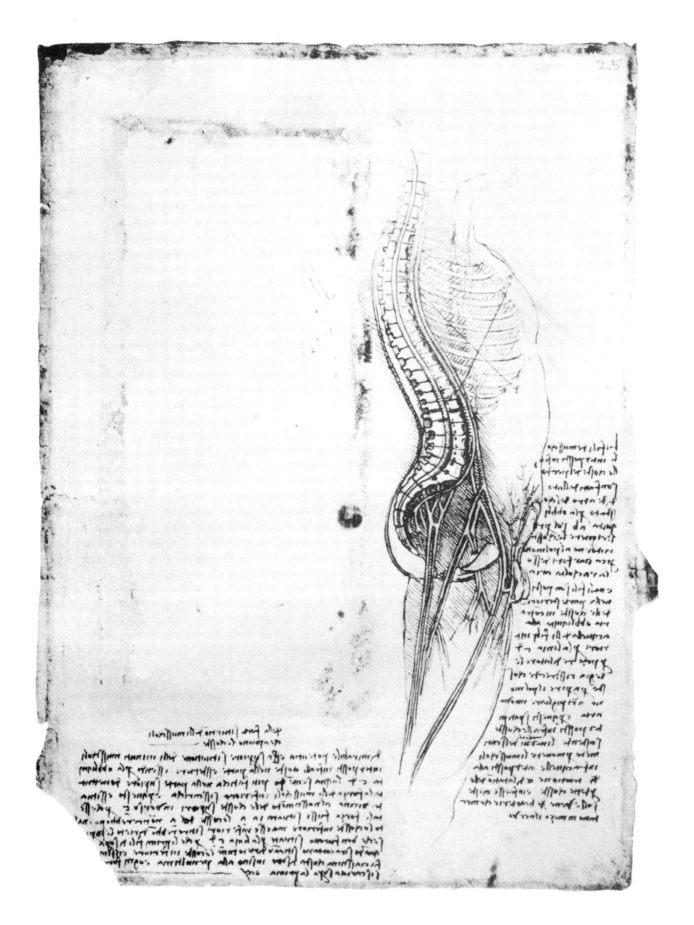

42. PERIPHERAL NERVES: LOWER EXTREMITY

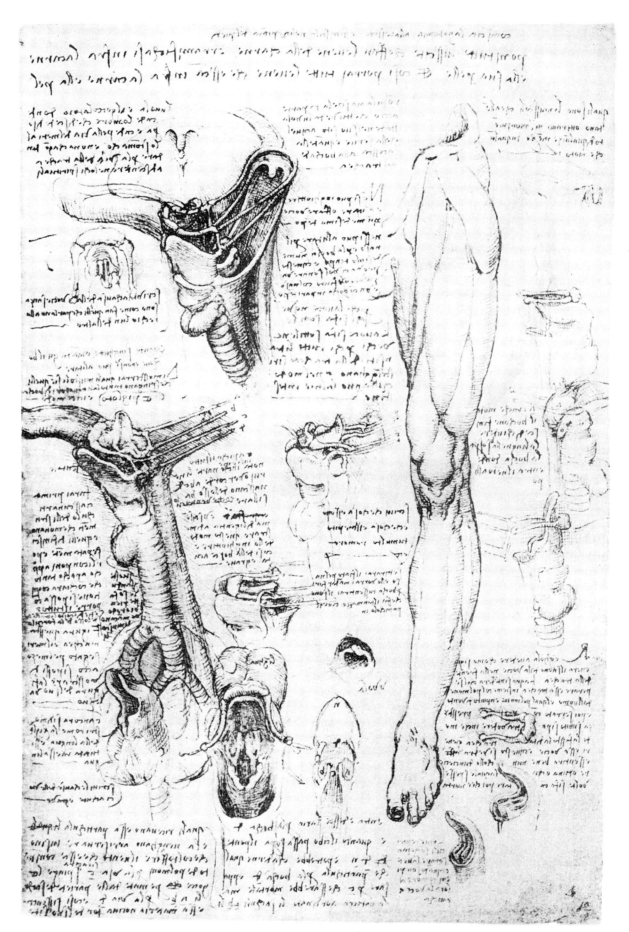

43. Respiratory System

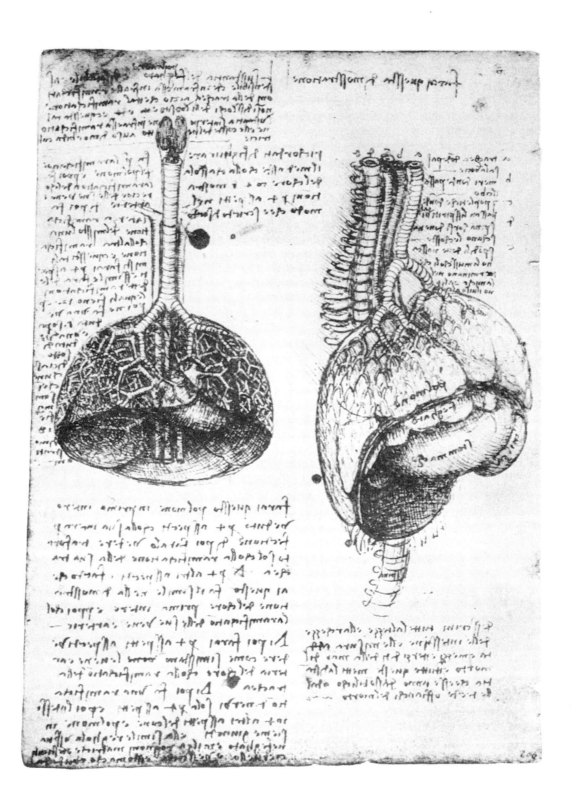

44. Respiratory System

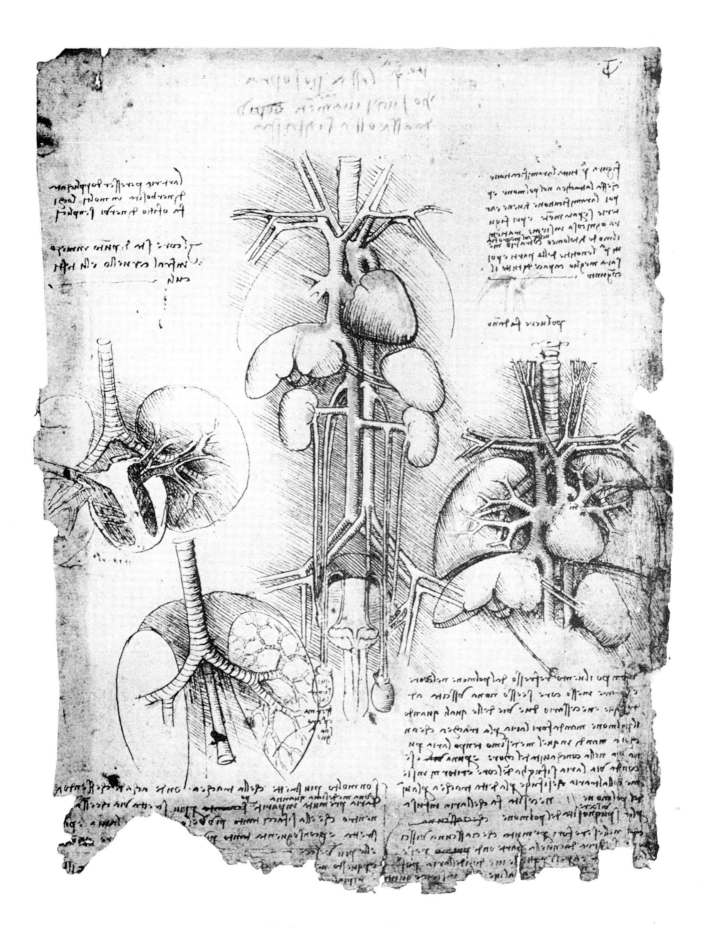

45. Respiratory System

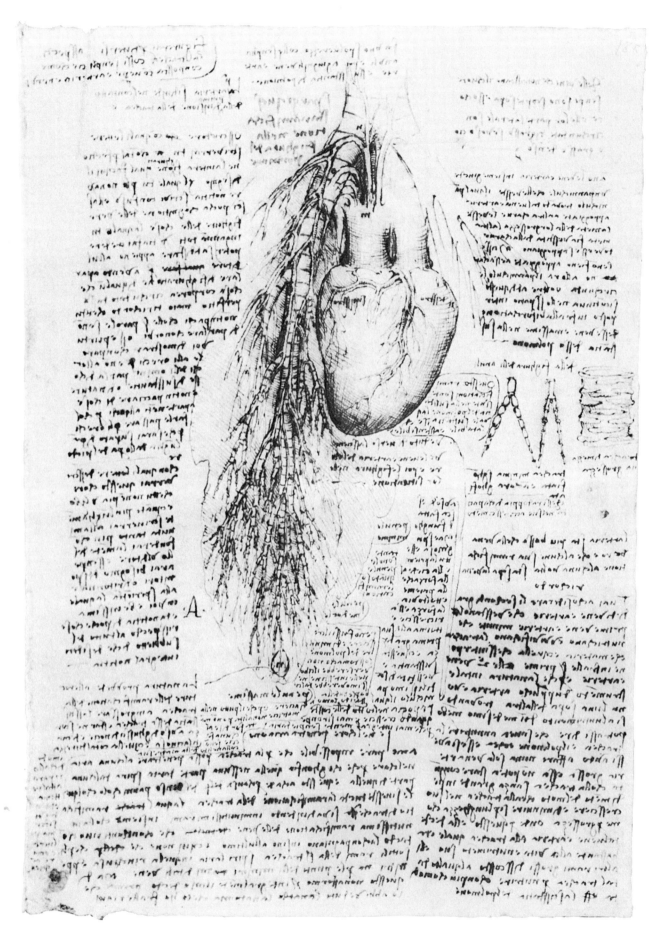

46. RESPIRATORY SYSTEM

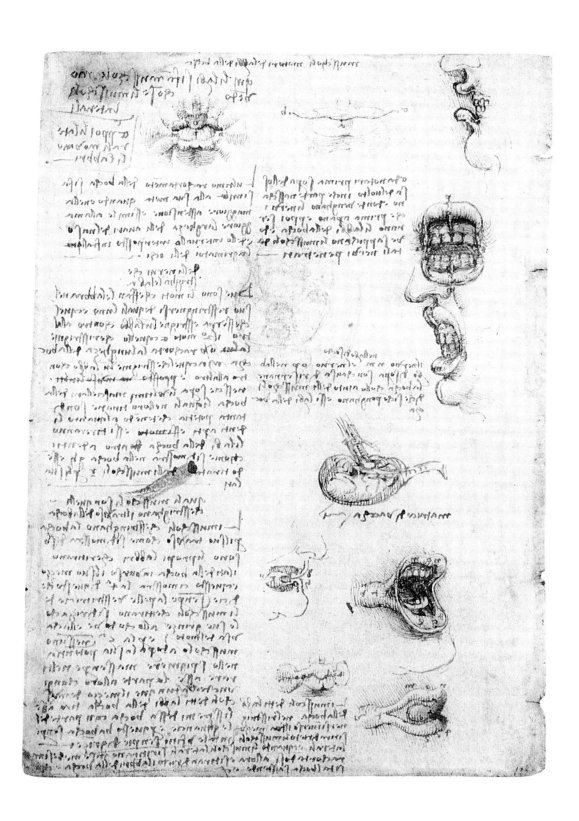

47. Alimentary System

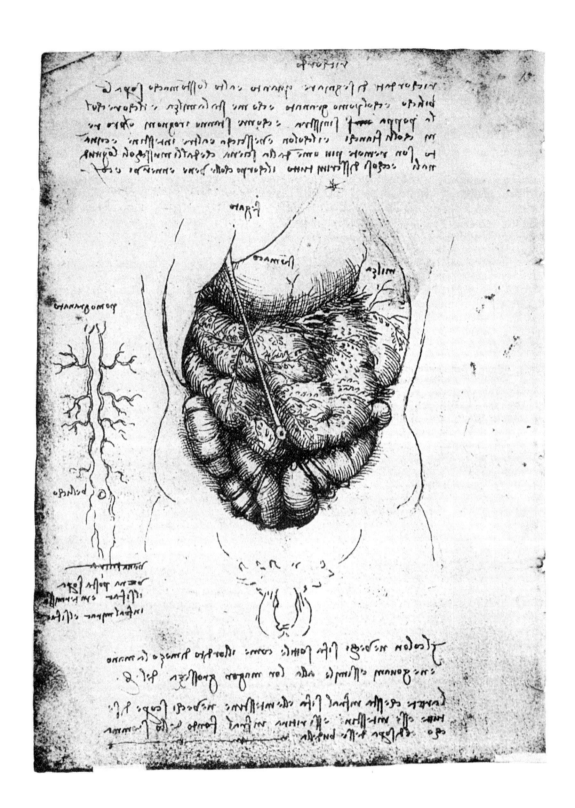

48. Alimentary System

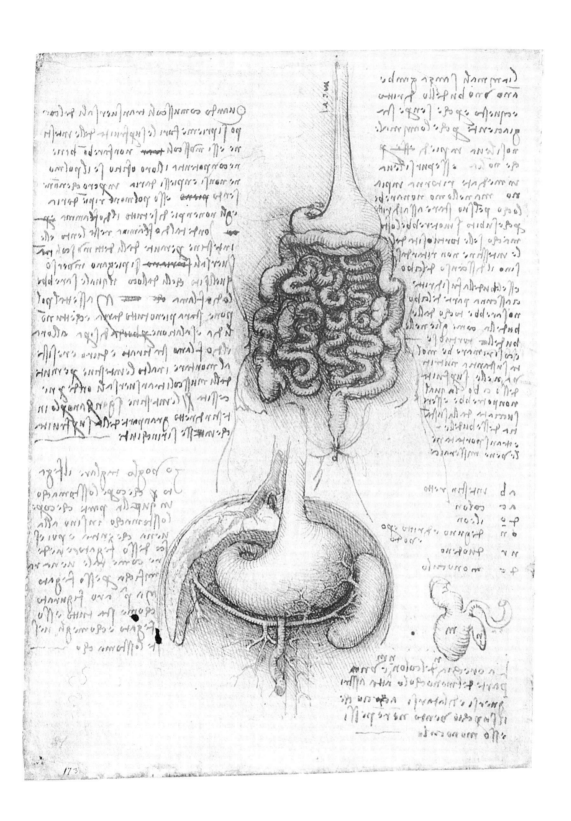

49. Alimentary System

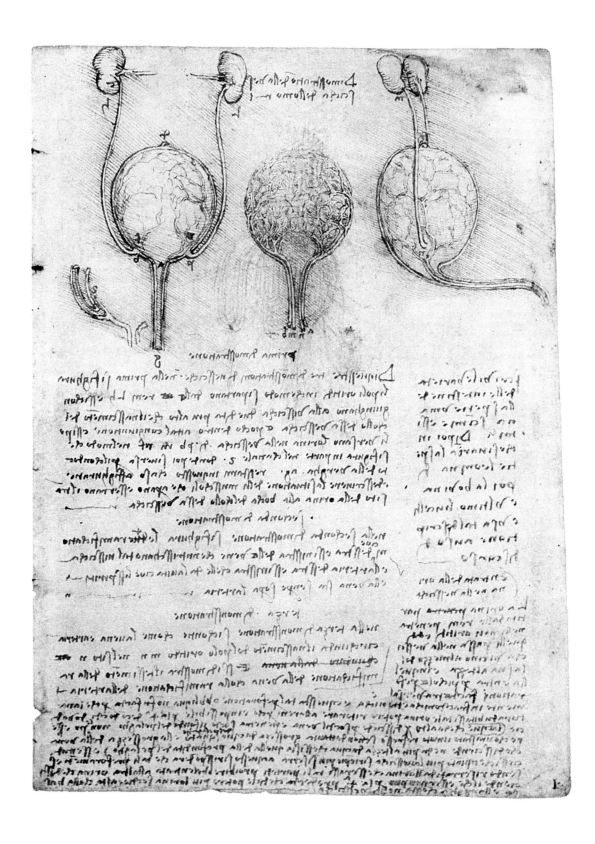

50. GENITO-URINARY SYSTEM

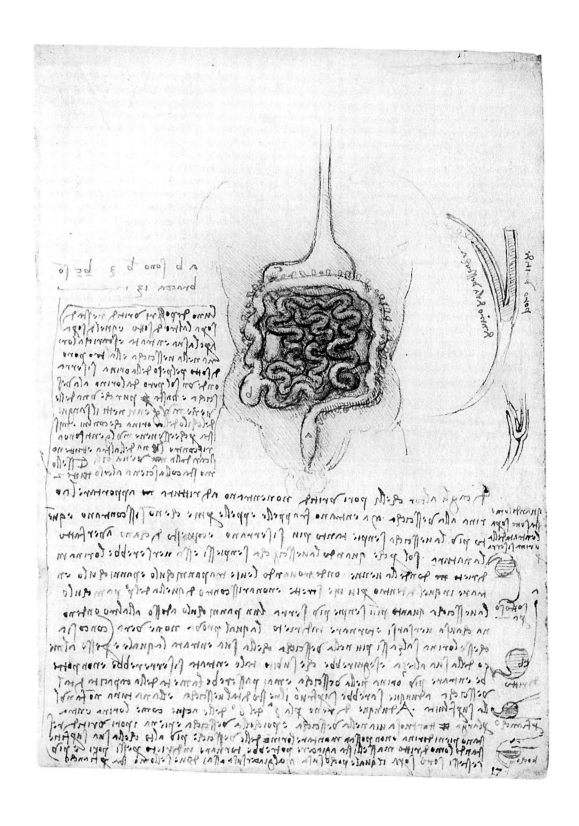

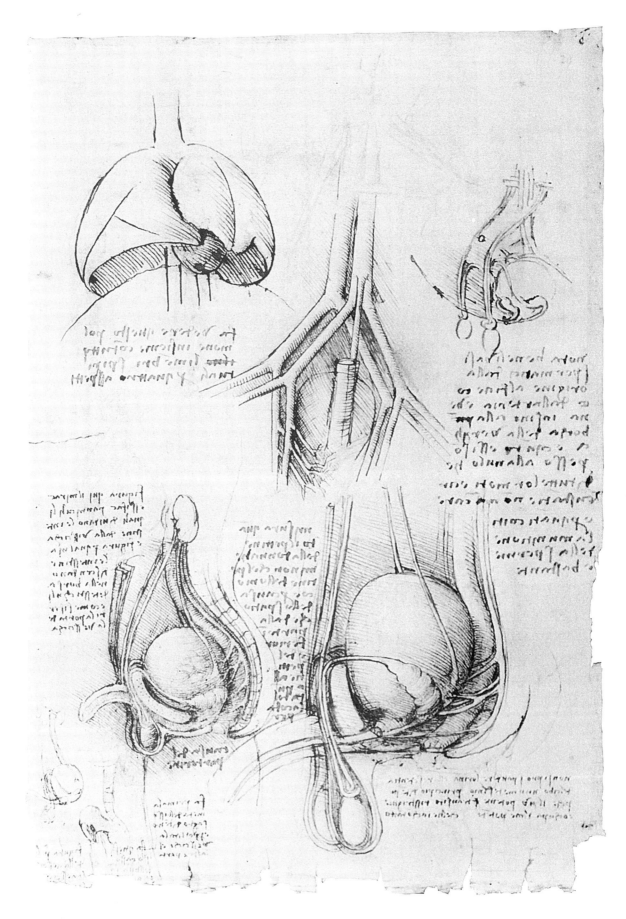

52. GENITO-URINARY SYSTEM

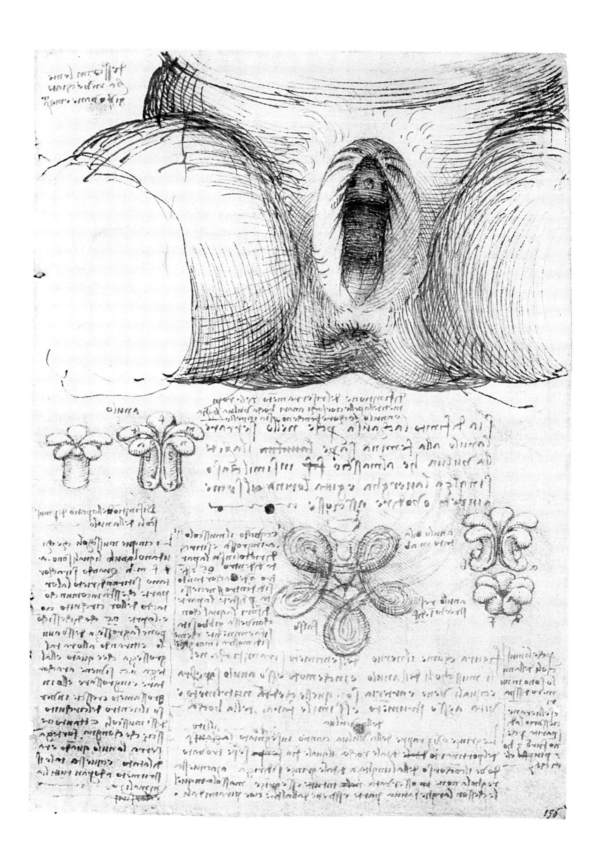

53. Genito-Urinary System

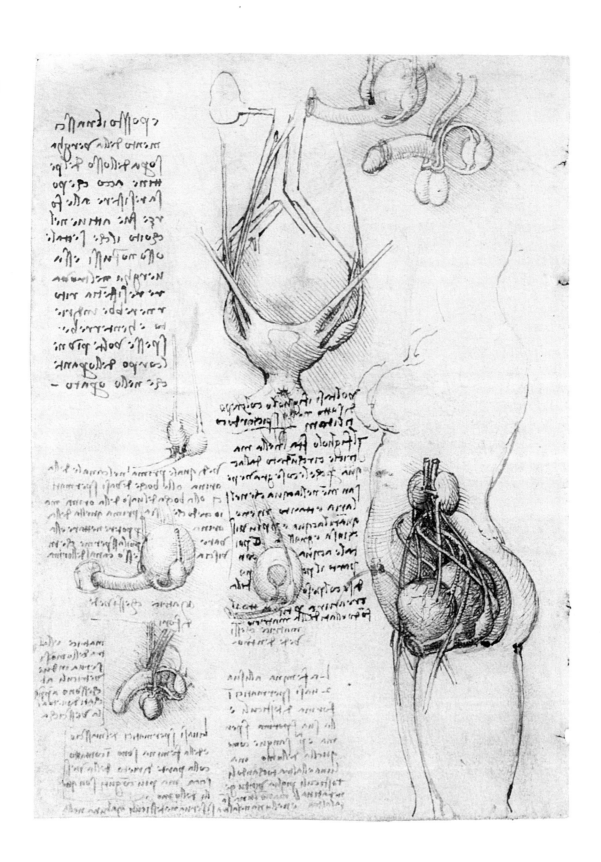

54. Genito-Urinary System

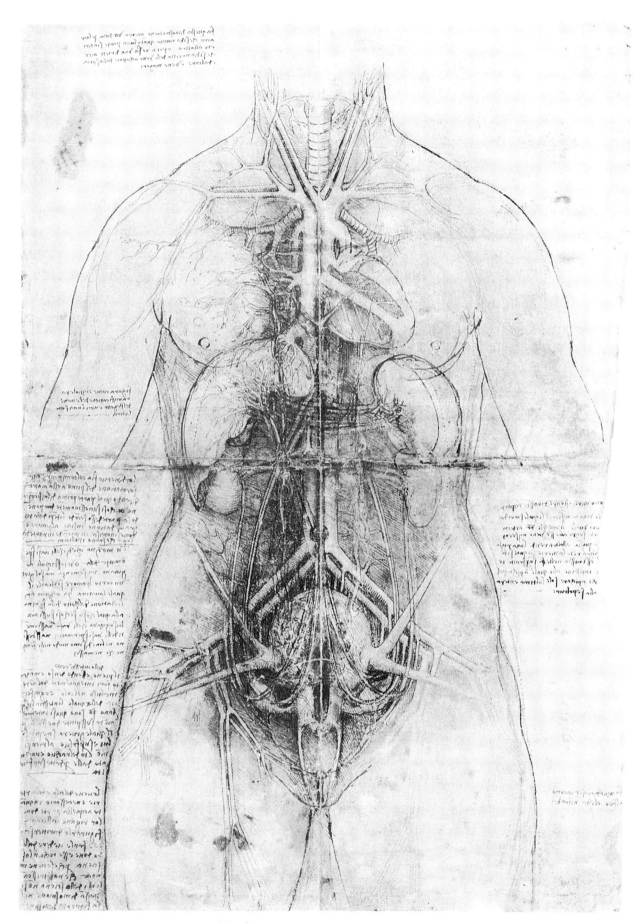

55. Genito-Urinary System

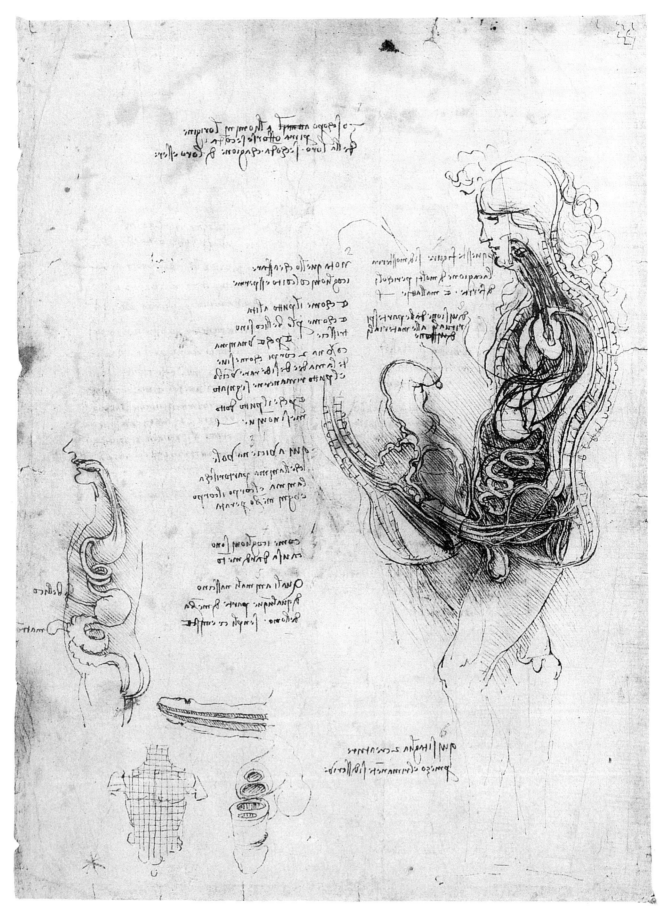

56. Genito-Urinary System

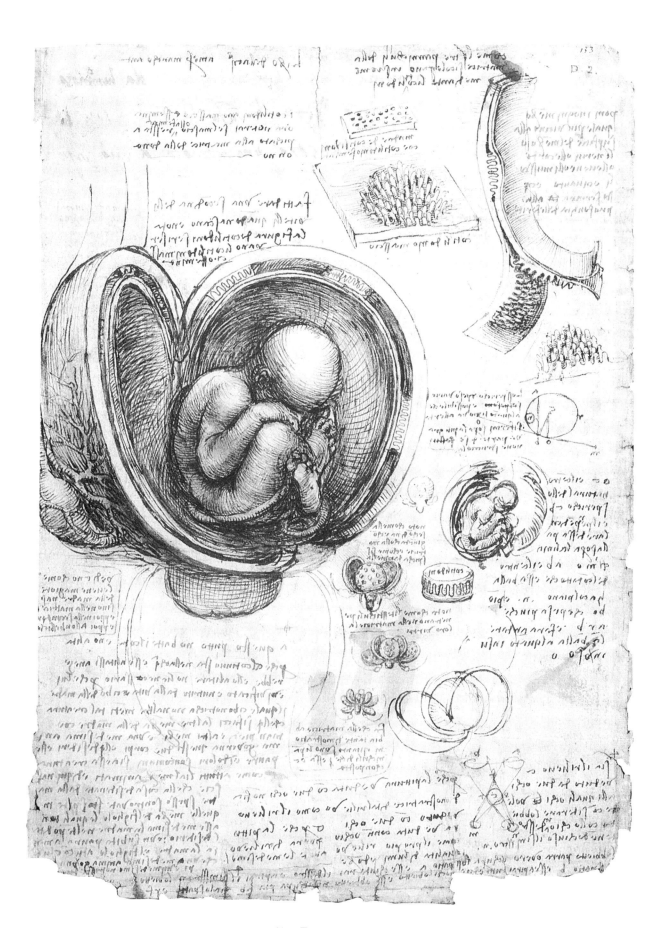

57. Embryology

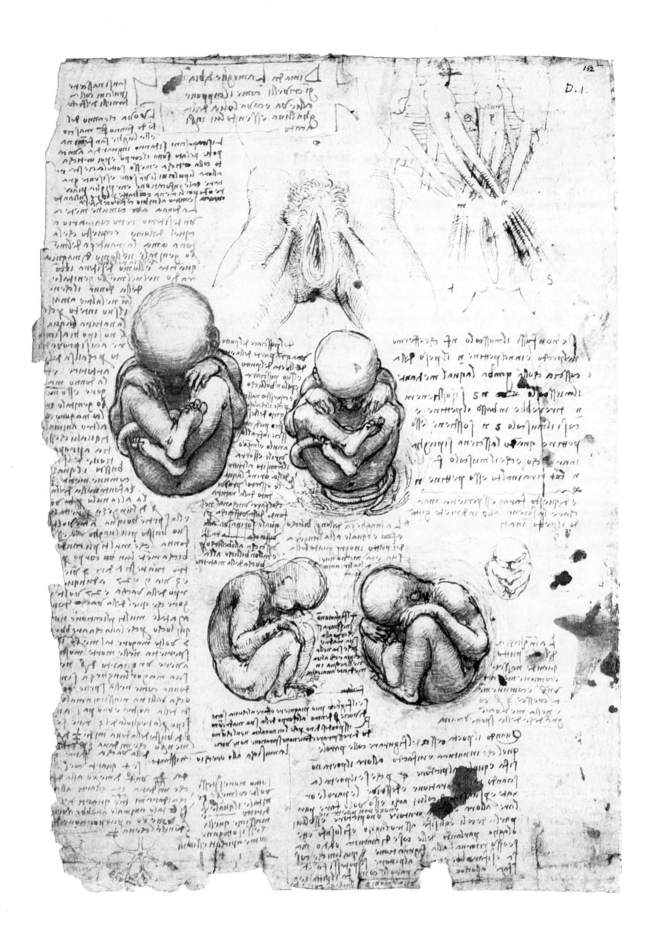

58. EMBRYOLOGY